Graphic Perception of Space

Frank Mulvey

Studio Vista London
Reinhold Book Corporation New York

Published in the United States of America 1969 by
Reinhold Book Corporation, 430 Park Avenue, New York, NY10022
and in Great Britain by Studio Vista Ltd, Blue Star House, Highgate Hill,
London N19
Library of Congress Catalog Card Number 69-16377
British SBN 289 79639 3
Set in 9D on 11pt Univers 689
Printed and bound in the Netherlands
by Drukkerij Reclame NV, Rotterdam
Designed by Frank Mulvey

If everybody saw things in the same way it would be a dull world.
It is not the intention in this volume to maintain that we all see and interpret alike. There is but one intention, to demonstrate some of the many ways of creating and interpreting spatial qualities.

Introduction

This book is primarily concerned with the spatial cues that help us interpret the visual world. There are examples of spatial relationships employed in architecture, interior design, photography and other visual media. Spatial organization of the printed word is also described.

THE EXPERIENCE OF SEEING IS AT THE SAME TIME A SPATIAL EXPERIENCE.

Our sense of sight permits us to judge where we are and helps us to direct our next movement. With sight we can judge distances; whether certain objects are near or far away.

Stop reading this page and look about you. Some objects may be close enough to reach out and touch. A ship on the horizon or clouds in the sky are more distant and out of reach.

How does the visual artist create illusions of space on his canvas? How do photographers and graphic designers control spatial effects in their various media? The following text and illustrations deal with this subject.

The material presented here should be read in a page-by-page sequence. In several instances you are asked to choose a 'correct' statement concerning a spatial interpretation of a given illustration. Your interpretation may be different from the choice described in the text as 'correct'. When this occurs you should review the illustration, keeping the **correct** answer in mind.

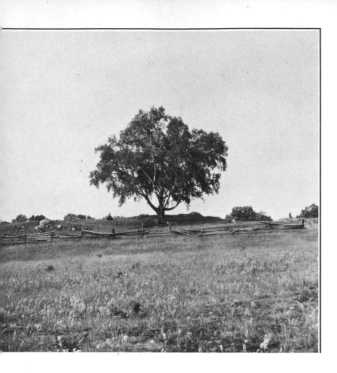

Plate 1

SIZE
Plate 1

For review purposes there are small reproductions of previous illustrations throughout the book. Some refer to a preceding page, while others are simply for review.

There is a glossary of terms on page 96.

This page is a sample of those that follow.

When asked to imagine something far away you might say, 'A tree on a distant hill'. (See lefthand illustration) Now imagine yourself standing within a few feet of the same tree. (Righthand illustration)

Make a 'correct' choice from the two statements below concerning these illustrations. Then turn the page.

A The tree in the lefthand illustration appears more distant from us.

B The trees in both illustrations appear the same distance from us.

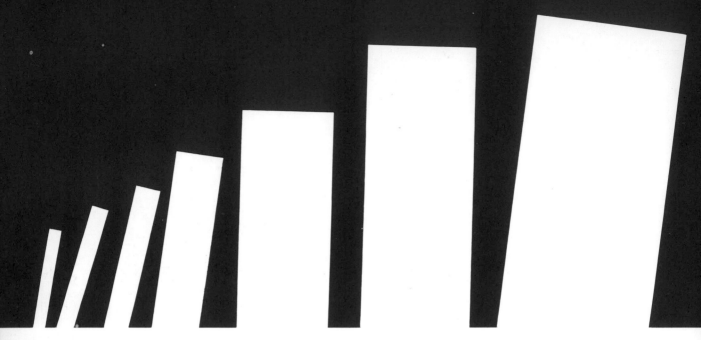

Plate 2

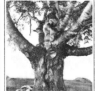

Plate 1

SIZE Plate 1 Choice A is **correct**.
The two pictures are views of the same tree. We can easily determine that the tree on the left, which appears smaller, is more distant from us. We conclude that change in the apparent size of an object can be due to a change in distance from the observer.

SIZE Plate 2
Here is a 'parade' of white shapes. Choose a statement below that points out spatial relationships.

A The largest white rectangle appears closest to us.

B All the shapes appear to be the same distance away.

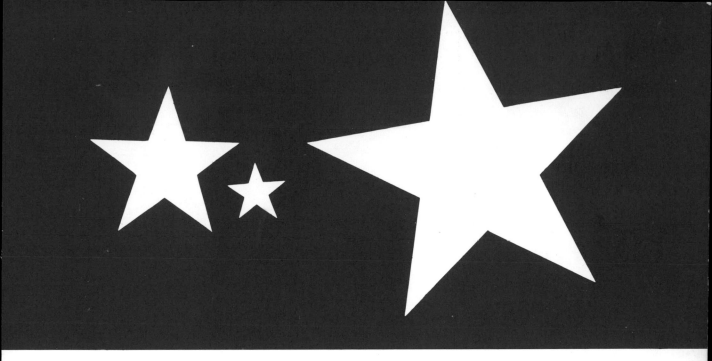

Plate 3

SIZE Plate 2 Choice A is **correct.**
The white shape on the right, being the largest of the
group, appears closest to us. The smaller rectangles stretch
away from us into the distance.

SIZE Plate 3
Which of the stars appears closest to us? Pick the correct
answer below.

A All three appear to be an equal distance from us. They
 differ only in size.

B The largest star appears closest.

Note: When illustrations on opposing pages distract your
attention, cover with a sheet of blank paper.

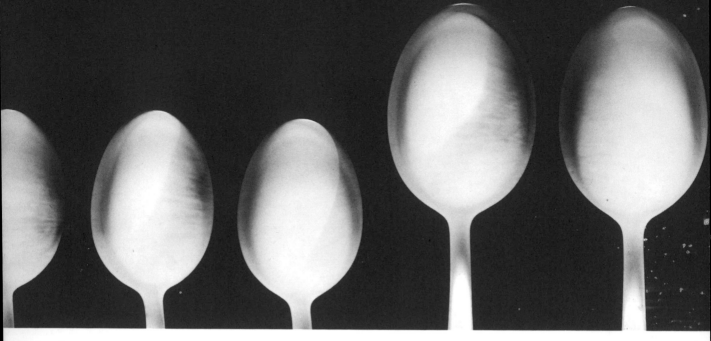

Plate 4

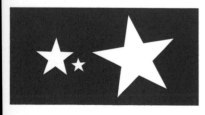

Plate 3

SIZE Plate 3 Choice B is **correct.**
Assume that the three stars are all equal in size but differ in
their respective distances from us. Thus the nearest star
appears to be the largest.

SIZE Plate 4
Choose the statement below that best describes the spatial
qualities found in this illustration. Let your choice again be
guided by size-distance relationships.

A The larger sized spoons appear closest to us.
B Both the teaspoons and soupspoons appear the same
 distance from us.

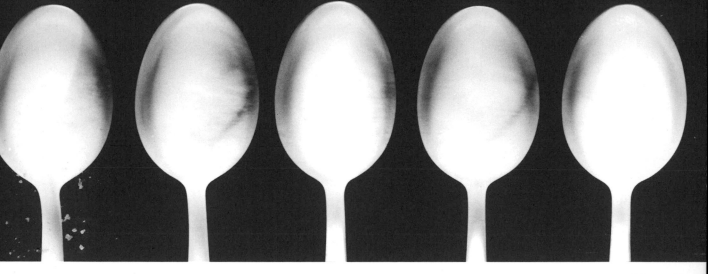

Plate 5

SIZE Plate 4 Choice A is **correct**.
The larger spoons appear closest. Remember that the size
of objects can suggest their relative spatial position.
SIZE Plate 5
The teaspoons in this illustration are all the same size
therefore they appear the same distance from us.

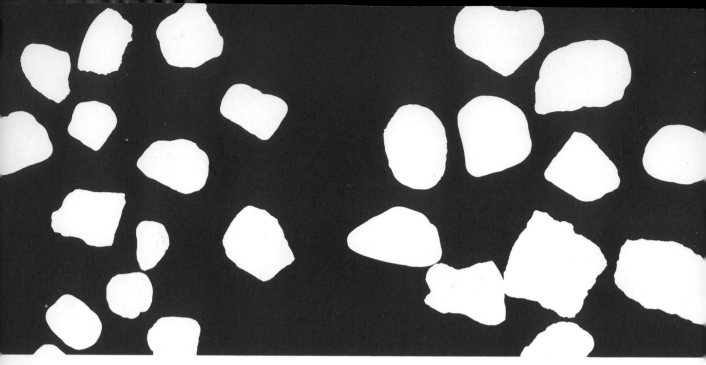

Plate 6

In this illustration there are two clusters of pebble-like shapes. In what ways do they differ?

One difference is their apparent distance from us. The smaller sized pebbles on the left appear to be more distant from us.

The following pages are concerned with typography, or the design of letter forms and their spatial possibilities. The printed word is seen everywhere, appearing not only in books, magazines and newspapers, but on commodities of every description. In fact, there is hardly a grapefruit or golfball that escapes the graphic imprint.

A walk through the business section of a city can involve us in a spatial experience of the printed word. Store windows reveal the printed word along with a display of wares. Traffic signs direct and warn us at every corner. Words and graphic symbols occupy just about every nook and cranny of our existence.

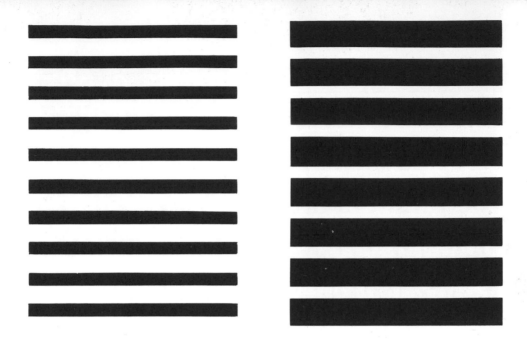

Plate 7

Graphic content for our mass media is the responsibility of a large assortment of individuals. In this group are the art director, media director, copy director, exhibition and display designer, visual communicator, film animator and typographer. They are all involved with the graphic presentation of words and pictures.

SIZE Plate 7

Which column of black lines appears closest to us? Make a choice below.

A The lefthand column appears closest.
B Both columns appear to be the same distance from us.
C The righthand column appears closest.

Away, with a shriek, and a roar, and a rattle, from the

among the dwellings of men and making the streets h

out in the meadows for a moment, mining in through

booming on in darkness and heavy air, bursting out ag

sunny day so bright and wide; away, with a shriek, an

rattle, through the fields, through the woods, through

through the hay, through the mould, through the clay,

rock, among objects close at hand and almost in the g

Plate 8

Plate 7

Plate 6

SIZE Plate 7 Choice C is **correct.**
What is the difference between the columns? It is the
comparative thickness in each set of lines. The heavier lines
on the right appear closest to us.

SIZE Plate 8
There is a similarity between the shaded words in this
illustration and the columns of black lines in Plate 7. Lines of
type can also be composed spatially. Notice that all the lines
in Plate 8 are similar in thickness so that, as a group, they all
appear to be positioned an equal distance from us.

The graphic artist working on a two-dimensional surface is
able to create the illusion of three dimensions. For the
photographer, three-dimensional qualities emerge from his
pictures almost magically. Hand-painted art that gives the
illusion of depth depends on a deliberate rendering by the
artist. For the graphic designer and others who deal with the
printed word, **type itself can be composed on the
printed page to suggest spatial illusion.**

the dwellings of men and making the streets hum, flash out in the
ws for a moment, mining in through the damp booming on in
ss and heavy air, bursting out again into the sunny day so bright
de ; away, with a shriek, and a roar, and rattle, through the fields,
1 the woods, through the corn, through the hay, through the mould,
1 the clay, through the rock, among objects close at hand and out
Away with a shriek, and a roar, and a rattle, from the town, burrowing
the dwellings of men and making the streets hum, flash out in the
ws for a moment, mining in through the damp booming on in
ss and heavy air, bursting out again into the sunny day so bright
de ; away, with a shriek, and a roar, and rattle, through the fields,
1 the woods, through the corn, through the hay, through the mould,
1 the clay, through the rock, among objects close at hand and out
Away, with a shriek, and a roar, and a rattle, from the town, burrow-
ong the dwellings of men and making the streets hum, flash out in
adows for a moment, mining in through the damp booming on in
ss and heavy air, bursting out again into the sunny day so bright
de ; away, with a shriek, and a roar, and rattle, through the fields,
1 the woods, through the corn, through the hay, through the mould,
1 the clay, through the rock, among objects close at hand and out
Away, with a shriek, and a roar, and a rattle, from the town,

Away, with a shriek, and a roar, and a ratt
from the town, burrowing among the
of men and making the streets hum, fla
out in the meadows for a moment, mini
in through the damp booming on in da
ness and heavy air, bursting out aga
into the sunny day so bright and wid
away, with a shriek, and a roar, and ratt
through the fields, through the woo
through the corn, through the hay, throu
the mould, through the clay, through t
rock, among objects close at hand and c

Plate 9

SIZE Plate 9
Compare the spatial relationship in the two columns above
with those in Plate 7. Notice that the heavier righthand
column in each illustration appears closer to us.
Note: The printer's terms 'type' and 'typography' will be
used in this text to describe the printed word. The phrase
'column of type' refers to several lines of type as a
compositional unit.
A few decades ago a handful of graphic artists began to
challenge traditional typography. Their innovations broke
several longstanding compositional rules. In doing this, they
liberated the printed page from its age-old two-dimensional
format. The possibilities of the printed word as a lively
design element are being explored in the development of
new media. Words can now be made to stretch, wobble,
bounce or gradually shrink in size, disappearing into the
glow of our TV picture tube.

efghijklmnopqrstuvwxyzabcdefghijklmnopqrstuvwxyzabcdefghijklmn
DEFGHIJKLMNOPQRSTUVWXYZABCDEFGHIJKLMNOPQRSTUVW

defghijklmnopqrstuvwxyzabcdefghijklmnopqrstuvwxyzabc
CDEFGHIJKLMNOPQRSTUVWXYZABCDEFGHIJKLMNO

defghijklmnopqrstuvwxyzabcdefghijklmnopqrstuv
CDEFGHIJKLMNOPQRSTUVWXYZABCDEFGHIJ

cdefghijklmnopqrstuvwxyzabcdefghijklmnop
CDEFGHIJKLMNOPQRSTUVWXYZABCD

cdefghijklmnopqrstuvwxyzabcdefghi
CDEFGHIJKLMNOPQRSTUVWXYZ

cdefghijklmnopqrstuvwxyza
CDEFGHIJKLMNOPQRSTU

abcdefghijklmnopqrstuvwxy
ABCDEFGHIJKLMNOPQRS

abcdefghijklmnopqrst
ABCDEFGHIJKLMNO

abcdefghijklmnop
ABCDEFGHIJKLM

abcdefghijklmr
ABCDEFGHIJK

Plate 10

SIZE Plate 10

Type sizes are measured in 'points' rather than in inches. One point equals approximately 1/72″. (See Glossary for definitions of unfamiliar terms). Shown above are examples of the same 'typeface', or letter style, in a range of point sizes. Sizes in this illustration increase from 8 pt (point) to 36 pt in the lower righthand column. Study these point size examples for their spatial qualities.

Away, with a shriek, and a roar, and a rattle, from the town, burrowing among the dwellings of men and making the streets hum, flash out in the meadows for a moment, mining in through the damp booming on in darkness and heavy air, bursting out again into the sunny day so bright and wide; away, with a shriek, and a roar, and rattle, through the fields, through the woods, through the corn, through the hay, through the mould, through the clay, through the rock, among objects close at hand and out again. Away, with a shriek, and a roar, and a rattle, from the town, burrowing among the dwellings of men and making the streets hum, flash out in the meadows for a moment, mining in through the damp booming on in darkness and heavy air, bursting out again into the sunny day so bright and wide; away, with a shriek, and a roar, and rattle, through the fields, through the woods, through the corn, through the hay, through the mould, through the clay, through the rock, among objects close at hand and out again. Away, with a shriek, and a roar, and a rattle, from the town,

Away, with a shriek, and a roar, and a rattle, from the town, burrowing among the dw of men and making the streets hum, flash out in the meadows for a moment, mining in through the damp booming on in darkness and heavy air, bursting out again into the sunny day so bright and wide; away, with a shriek, and a roar, and a rattle, through the fields, through the woods, through the corn, through the hay, through the mould, through the clay, through the rock, among objects close at hand and out

Plate 9

abcdefghijklmnopqrstuvwxyzabcdefghijklmnc
ABCDEFGHIJKLMNOPQRSTUVWXYZABCDE

abcdefghijklmnopqrstuvwxyzabcdefghi
ABCDEFGHIJKLMNOPQRSTUVWXYZA

abcdefghijklmnopqrstuvwxyzabcde
ABCDEFGHIJKLMNOPQRSTUVWX

abcdefghijklmnopqrstuvwx
ABCDEFGHIJKLMNOPQR

abcdefghijklmnopqrs
ABCDEFGHIJKLMNC

abcdefghijklmnop
ABCDEFGHIJKLN

Plate 11

SIZE Plate 11
A typographical illusion of space is demonstrated here by
using vertical lines of type. A step-by-step increase in point
size suggests a gradual approach towards us.

REAR

NEAR

Plate 12

SIZE Plate 12

What spatial position does 'NEAR' occupy in the above illustration? If you saw 'NEAR' as closer—**correct**.
In the next two illustrations we shall see how spatial qualities can be achieved by using type that varies in width rather than in height.

efghijklmnopqrstuvwxyzabcdef **abcdefghijklmnopqrstuvwxyza** abcdefghijklmnopqrstuvwxyzabcdef **abcdefghijklmnopqrstuvwxyza**
efghijklmnopqrstuvwxyzabcdef **abcdefghijklmnopqrstuvwxyza** abcdefghijklmnopqrstuvwxyzabcdef **abcdefghijklmnopqrstuvwxyza**
efghijklmnopqrstuvwxyzabcdef **abcdefghijklmnopqrstuvwxyza** abcdefghijklmnopqrstuvwxyzabcdef **abcdefghijklmnopqrstuvwxyza**
efghijklmnopqrstuvwxyzabcdef **abcdefghijklmnopqrstuvwxyza** abcdefghijklmnopqrstuvwxyzabcdef **abcdefghijklmnopqrstuvwxyza**
efghijklmnopqrstuvwxyzabcdef **abcdefghijklmnopqrstuvwxyza** abcdefghijklmnopqrstuvwxyzabcdef **abcdefghijklmnopqrstuvwxyza**
efghijklmnopqrstuvwxyzabcdef **abcdefghijklmnopqrstuvwxyza** abcdefghijklmnopqrstuvwxyzabcdef **abcdefghijklmnopqrstuvwxyza**

defghijklmnopqrstuvwxyza **abcdefghijklmnopqrstuvw** abcdefghijklmnopqrstuvwxyza **abcdefghijklmnopqrstuvw**
defghijklmnopqrstuvwxyza **abcdefghijklmnopqrstuvw** abcdefghijklmnopqrstuvwxyza **abcdefghijklmnopqrstuvw**
defghijklmnopqrstuvwxyza **abcdefghijklmnopqrstuvw** abcdefghijklmnopqrstuvwxzya **abcdefghijklmnopqrstuvw**
defghijklmnopqrstuvwxyza **abcdefghijklmnopqrstuvw** abcdefghijklmnopqrstuvwxyza **abcdefghijklmnopqrstuvw**
defghijklmnopqrstuvwxyza **abcdefghijklmnopqrstuvw** abcdefghijklmnopqrstuvwxyza **abcdefghijklmnopqrstuvw**
defghijklmnopqrstuvwxyza **abcdefghijklmnopqrstuvw** abcdefghijklmnopqrstuvwxyza **abcdefghijklmnopqrstuvw**

defghijklmnopqrstuvw **abcdefghijklmnopqrst** abcdefghijklmnopqrstuvw **abcdefghijklmnopqrstu**
defghijklmnopqrstuvw **abcdefghijklmnopqrst** abcdefghijklmnopqrstuvw **abcdefghijklmnopqrstu**
defghijklmnopqrstuvw **abcdefghijklmnopqrst** abcdefghijklmnopqrstuvw **abcdefghijklmnopqrstu**
defghijklmnopqrstuvw **abcdefghijklmnopqrst** abcdefghijklmnopqrstuvw **abcdefghijklmnopqrstu**
defghijklmnopqrstuvw **abcdefghijklmnopqrst** abcdefghijklmnopqrstuvw **abcdefghijklmnopqrstu**
defghijklmnopqrstuvw **abcdefghijklmnopqrst** abcdefghijklmnopqrstuvw **abcdefghijklmnopqrstu**

Light	Extra Bold	Medium	Bold
cdefghijklmnopqrst	**abcdefghijklmnopq**	abcdefghijklmnopqrst	**abcdefghijklmnopq**

Plate 13

SIZE Plate 13

Each of the four columns above contains the same sequence of point sizes, but notice that each column differs in visual weight.

In column 1 the letters appear thin and light weight. The lines of type in column 2 are noticeably much thicker and heavier.

Printers describe type that is light in weight as having a 'light face'. Type that is thick and heavy in appearance is labelled 'bold face' (column 4) and 'extra bold' (column 2). Between the variations of light and bold is 'medium face' (column 3). Study the four columns for their comparative spatial qualities. Which column appears closest to us? Base your decision as to their relative spatial positions upon their comparative 'weights'.

If you chose columns 2 and 4—**correct.**

next day the Bird would not go for the wood, saying she had been slave long enough; for once they must change about and try another plan. And however well the Mouse and the Sausage begged earnestly against it, the Bird

so they tossed up, and it fell to the lot of the Sausage to fetch wood, while the Mouse had to cook, and the Bird to procure water. What happened? The Sausage went forth into the forest, the Bird made the fire, the

Plate 14

abcdefghijklmnopqrstuvwxyza
ABCDEFGHIJKLMNOPQRSTU

abcdefghijklmnopqrstuv
ABCDEFGHIJKLMNOPQ

abcdefghijklmnopqr
ABCDEFGHIJKLMN

abcdefghijklmno
ABCDEFGHIJKL

Plate 10

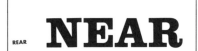

Plate 12

The two type areas above are set in a similar point size. The top five lines are set in a light face Univers type style, the five lines below are set in bold face Univers. (Univers is the name of this particular type style.)
Which body of type appears closer to us? Make a choice from the statements below.
A The light face type appears closer.
B The bold face type appears closer.
Choice B is **correct.**
We have seen how words of different sizes and weights can be utilized as elements in 'spatial typography'. These same visual principles could also be applied to architecture, interior design and other visual arts.

Plate 15

VALUE Plate 15

The next illustrations show how value relationships can help determine spatial position.

Value relationship is defined here as the comparative bright-ness or darkness of areas.

A scale of values moves from white through gradually darkening greys to black.

The illustration above shows two circles of the same size and grey value. Due to their similarities in size and value, neither circle appears the closer to us.

Plate 16

VALUE Plate 16

The two circles are a similar size. One is darker and stands out against the white background.

Which circle in the above illustration appears closer to us?

A The darker circle appears closer.
B The lighter circle on the left is closer to us.
C Both circles appear the same distance from us.

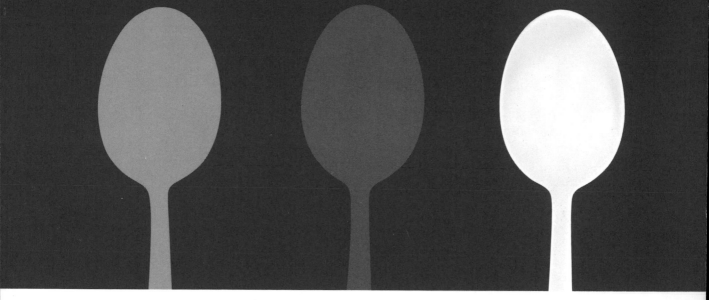

Plate 17

VALUE Plate 16 Choice A is **correct.**
The circles are equal in size but not in value. The darker circle stands out in contrast with the white background and appears closer to us.

VALUE Plate 17
The three spoons are equal in size but not in value. Seen against a black background, which spoon appears closest to us?

The white spoon appears closest.

In comparison, the grey valued spoons tend to merge into the dark background.

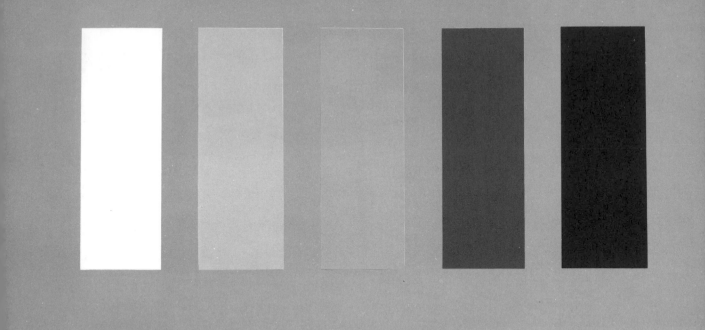

Plate 18

Photographers can control the value relationships in their work by means of lighting, exposure, development and other techniques.

Some photographs are light grey in overall value while others may be on the dark side of the value scale. They can also possess a full value range, from white through several shades of grey to solid black. The silhouette photograph contains only white and black with no intermediate greys at all.

Spatial effects can be manipulated in a photograph through the conscious control of value relationships.

VALUE Plate 18

Which two rectangles contrast most with the grey background? Which rectangle appears most distant from us? Why do some rectangles appear closer to us?

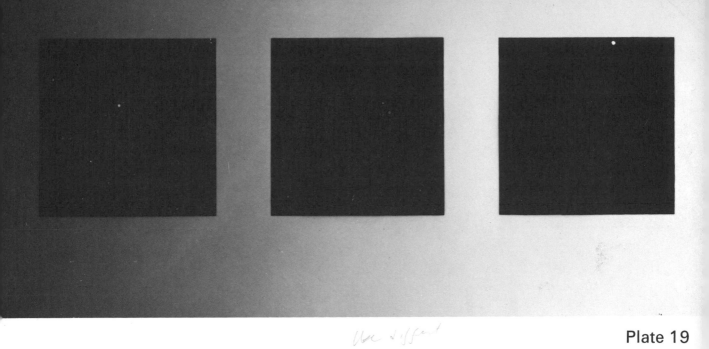

Plate 19

VALUE Plate 18 Both the white and black rectangles contrast most with the grey background. Both appear closer to us than any of the others. The middle rectangle blends into the grey background and appears most distant from us.

VALUE Plate 19
In this illustration a noticeable tonal change takes place in the background area. Assuming that all three squares are black, which one appears closest to us? Make a choice below, based on value relationships.

A The three squares are similar in size and value. All three appear to be the same distance from us.

B Although similar in size and value, the righthand square appears closest. The contrasting background value causes this square to stand out most clearly.

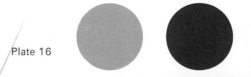

Plate 15

Plate 16

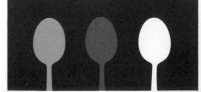

Plate 17

23

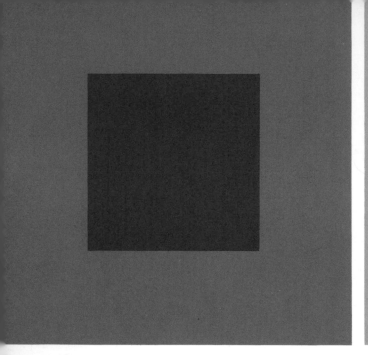

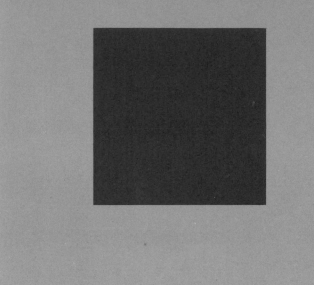

Plate 20

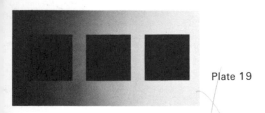

Plate 19

VALUE Plate 19 Choice B is **correct**.
The apparent spatial position of each square can be deter-
mined by the degree of tonal contrast with its local back-
ground value.

VALUE Plate 20
Which black square appears closest to us?
It is the righthand square, which contrasts most with the
lighter grey background.

VALUE Plate 21
Opposite is an example of a pattern having spatial qualities
based on value difference. As an idea for a fabric pattern or
wall covering design, it could give the illusion of depth to an
otherwise flat surface.

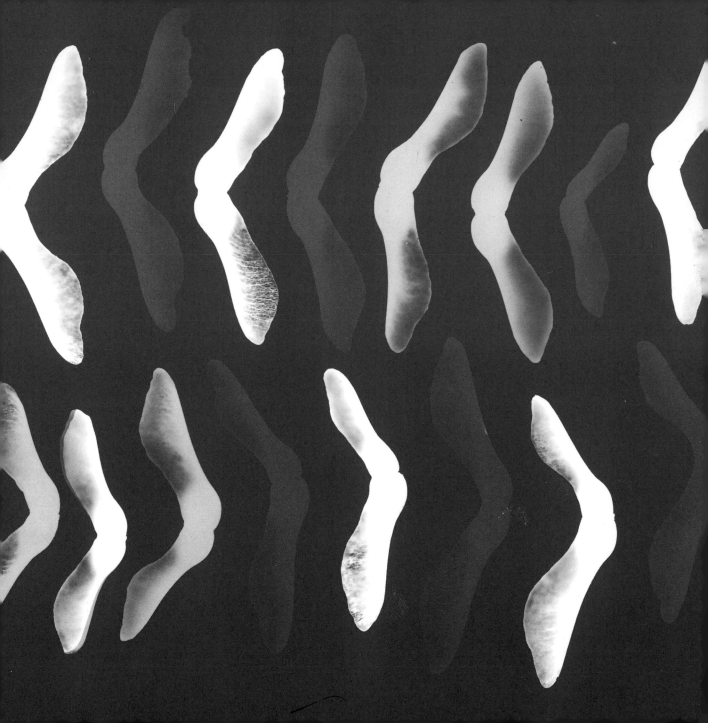

Plate 22

VALUE Plate 22
The letters are all black in the above illustration and are of
the same point size. Select the correct statement below.
A As a group, the words on the left appear closer.
B Both left and righthand groups appear to be positioned
 the same distance from us. This is due to their similarity
 in size and shade of black.

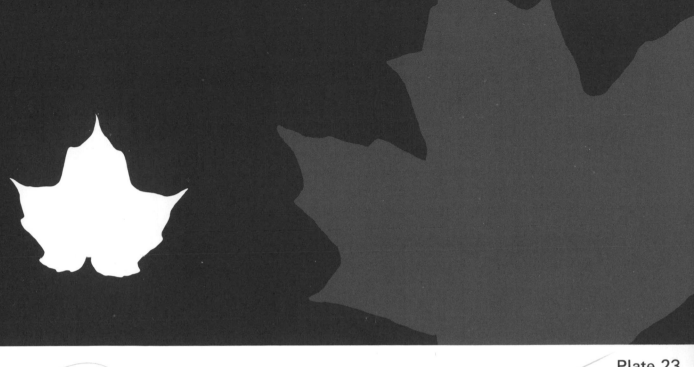

Plate 23

VALUE Plate 22 Choice A is **correct**.
The words at the left appear closest. While the letters in both
groups are black and of similar size, their backgrounds differ
in value. The lighter grey background contrasts most with
the letters in black and makes them appear nearest to us.
VALUE Plate 23
The above illustration contains two leaf shapes that differ in
size and value. Which leaf appears closer to us? Consider
tonal contrast as the most important factor.

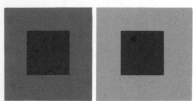

Plate 20

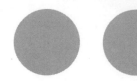

Plate 15

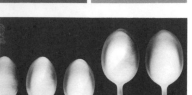

Plate 4

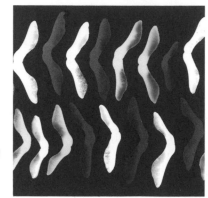

Plate 21

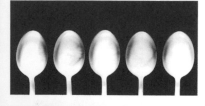

Plate 5

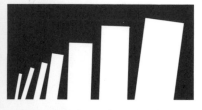

Plate 2

VALUE Plate 23 The small white leaf appears closer. Although the grey leaf is much larger, the dark tone causes it to merge with the black background. We can see how a larger form can be made to appear more distant by matching its value closely to that of the background area.

Controlled relationships of value, such as the example above, can be useful to the film maker, stage and display designer. Apparent depth can be exaggerated or diminished by controlled lighting.

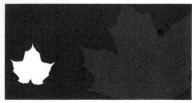

Plate 23

Plate 16

Plate 11

28

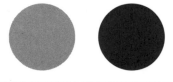

Plate 24

We have now studied examples of spatial illusion obtained through differences in **size** and **value.** The following plates will show how the **position** of an object within an area can suggest spatial qualities.

Imagine we are looking at the distant horizon. As we lower our gaze from the horizon, the objects we see are progressively nearer to us. Finally we can look directly downwards to the ground beneath our feet. Thus, with hardly any conscious effort, we can easily scan what is far from us and what is close at hand. When we view a realistic painting a similar experience occurs. We usually associate the top of a painting with distant areas, and the bottom part with those close at hand.

POSITION Plate 24

The illustration above demonstrates the illusion of distance due to position. Which square appears to be closer to us?

The bottom square can be interpreted as closer.

A difference in size is used here to reinforce the illusion.

Plate 25

POSITION Plate 25

Remember that the location of a shape or an area may help us in judging its apparent position in depth. Which white shape in the above illustration appears closest to us? Choose from the answers below.

A Both white shapes appear to be the same distance away from us.

B The lower white shape appears closer.

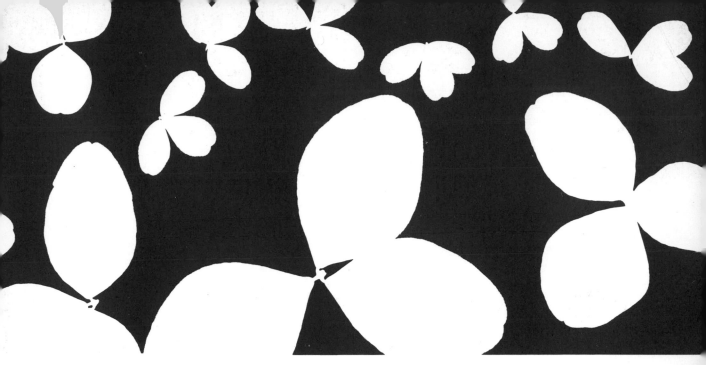

Plate 26

POSITION Plate 25 Choice B is **correct.**
The lower white shape appears closer to us for two reasons.
1 It is positioned at the bottom.
2 This shape is much thicker than the narrow top line, thus
 emphasizing a size difference.

POSITION Plate 26
The illustration above contains several clover leaf shapes.
Decide if the statement below is **correct.**
The small clover leaves at the top appear more distant than
the large ones on the bottom.

NOSE

HAND

FOOT

Plate 27

POSITION
Decide which word appears closest.

Plate 27

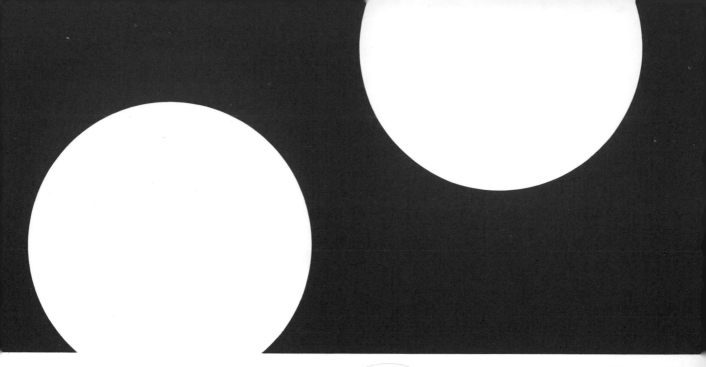

Plate 28

POSITION Plate 27 The lowest word in this layout appears closest. This is due to its position and larger size.

POSITION Plate 28

These two circles have the same diameter. Based on their position, which appears closest to us?

A Due to their similarities in size and value, the two circles appear the same distance away.

B Based on position, the upper circle can be interpreted as more distant from us.

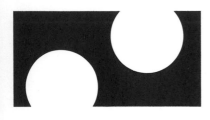

SAY
SAG

Plate 29

Plate 28

Plate 24

Plate 25

POSITION Plate 28 Choice B is **correct.**
The upper circle may be interpreted as the more distant. The opposite illusion is also possible, with the upper circle appearing closer to us.

This type of spatial ambiguity is often utilized by artists. Their paintings can thus be experienced as 'spatial play-grounds' with shapes and areas that appear to shift and interchange their positions.

POSITION Plate 29
The two words shown here are the same size. Which word appears more distant due to position?

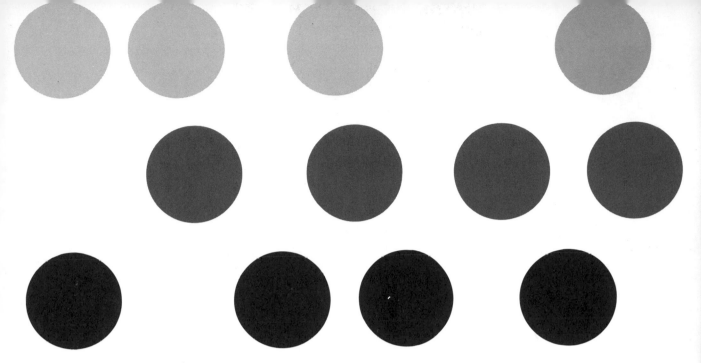

Plate 30

POSITION Plate 29 The top word 'SAY' appears to
be more distant. This uppermost area is equivalent to an
imaginary distant horizon.

POSITION Plate 30
These circles are all the same size. Which of the horizontal
rows appears closest?
Base your choice on both position and value qualities.

A The top row appears closest.
B The bottom row appears closest.

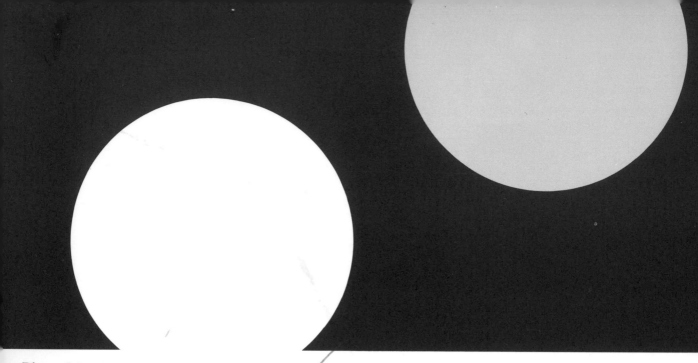

Plate 31

POSITION Plate 30 Choice B is **correct**.
POSITION Plate 30 Choice B is **correct**.
This row is at the bottom and so appears closest. Rein-
forcing this illusion is the value contrast against a white
background.
POSITION Plate 31
These two circles have the same diameter.
Which appears closer? Why?

Plate 30

he scene with g

en second blas

Plate 32

POSITION Plate 31 The lower circle appears to be closer due to its position. The upper circle blends with the background, and this makes it appear distant.

POSITION Plate 32
Both lines of type are the same point size. Which line appears closer to us? Give two reasons for your choice.

Plate 33

the scene with g

ten second blas Plate 32

Plate 25

POSITION Plate 32 The bottom line appears closer. This is due to:

1 Position.
2 Degree of value contrast between the black type and its white background.

In this example the background shifts in value while both lines of type are the same black value.

POSITION Plate 33

Which white area appears closer to us?

It is possible to visualize the bottom white line as closer, although it is much thinner.

A comparison between the above illustration and Plate 25 reveals:

1 A difference of thickness in the two thin lines.
2 The thicker of these two lines is found in Plate 33. This helps create the illusion of nearness noted in Plate 33.

itting ne **Happily i**

rom the i **clear and**

green hills find the c

eached ir headed f

iamond. accent.

Plate 34

POSITION Plate 34

On the left is another example of how position may influence our spatial interpretation of typography. It is the bottom two lines on the left that appear closest to us. Reinforcing their apparent nearness is a strong contrast in value between the black type and its white background.

On the right a different spatial illusion is suggested. The top lines appear closest, with a strong value contrast forcing them to stand out.

In the righthand example it is **value** contrast, not **position**, that determines the spatial relationship of the words.

39

BTZPLKJ

KVD RS UJC

Plate 35

POSITION Plate 35
Two lines of different sizes of type are shown above. Which
line appears nearer to us? Why?

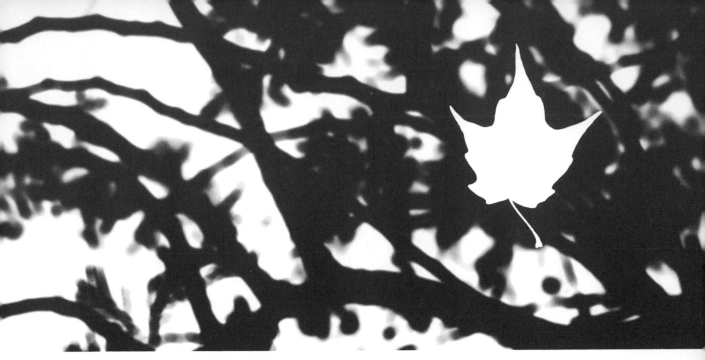

Plate 36

POSITION Plate 35 The bottom line of type appears closer. Two factors contributing to this illusion are:

1 Position.
2 Value contrast between type and backgrounds. Although the topmost letters are much larger, they appear to merge into the dark background.

EDGE Plate 36

Starting with this illustration will be several examples that utilize forms with distinct and indistinct outlines or edges. In photography the terms 'in-focus' and 'out-of-focus' are used to describe these qualities.

A white leaf shape is seen against an indistinct background in this illustration. The edge of this leaf is relatively well defined and we can visualize it as placed in front of the blurred background.

Plate 33

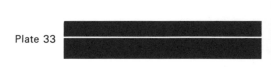

Plate 34

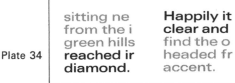

sitting ne
from the i
green hills
reached ir
diamond.

Happily it
clear and
find the o
headed fr
accent.

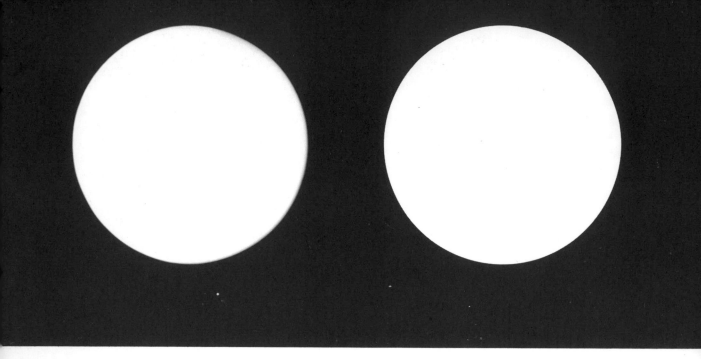

Plate 37

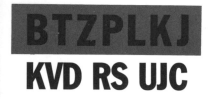

Plate 35

EDGE Plate 37
The two circles are white and similar in size. In what way are they different?
One is sharp edged, the other is blurred.
Make a choice from the statements below regarding their relative spatial qualities.

A The two circles are similar in size and appear an equal distance from us.

B The blurred circle appears more distant.

MIST

CRISP

Plate 38

EDGE Plate 37 Choice B is **correct**.
That which is close-at-hand can be seen distinctly. Distant objects appear hazy and indistinct. There are exceptions to this.

Try the following experiment: focus attention on your finger, holding it about ten inches away from your eyes. At the same time, extend your other hand straight out in front of you. While you focus on the nearest held finger, notice how indistinct and blurred your other hand appears. Now focus attention on your fully extended hand. It will appear distinct and sharp, while your nearest finger becomes blurred. What does this experiment in eye focussing mean? It obviously illustrates how a nearby object may sometimes appear indistinct or out-of-focus, depending on where we decide to focus our attention. The visual artist can make use of these qualities, either for the purpose of emphasis or to express depth in his work.

EDGE Plate 38
Study this illustration for spatial qualities.

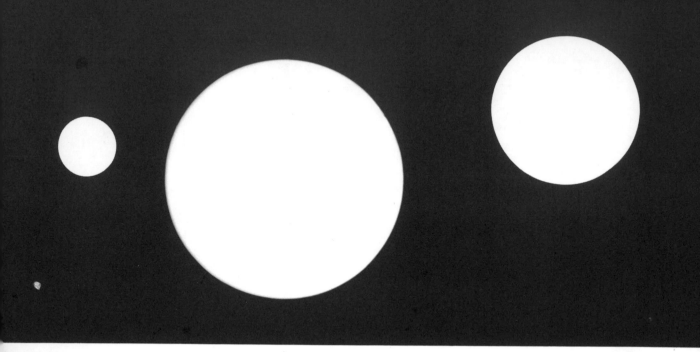

Plate 39

EDGE Plate 39
Which shape appears closest to us?
Are the spatial relationships changeable and ambiguous?
We may conclude that they do shift. At one moment a shape
will appear closer, at another more distant than other circles
in the illustration.

EDGE Plate 40
Assume that the two circles on the opposite page are the
same size.
Which circle appears closer to us?
Think of these shapes as **solid** forms, not as shadows,
reflections or holes in a black surface.

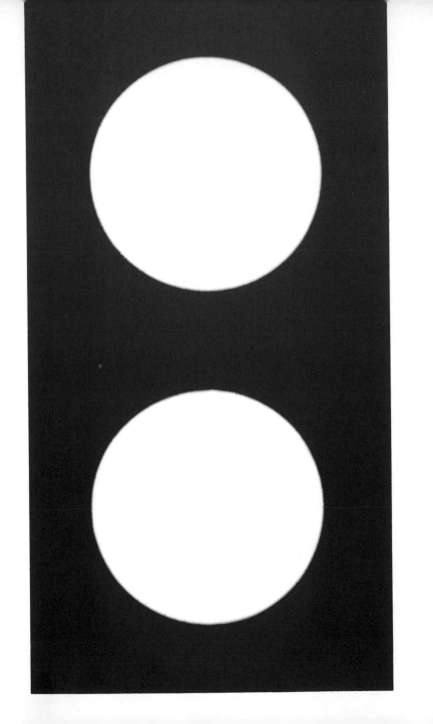

Plate 40

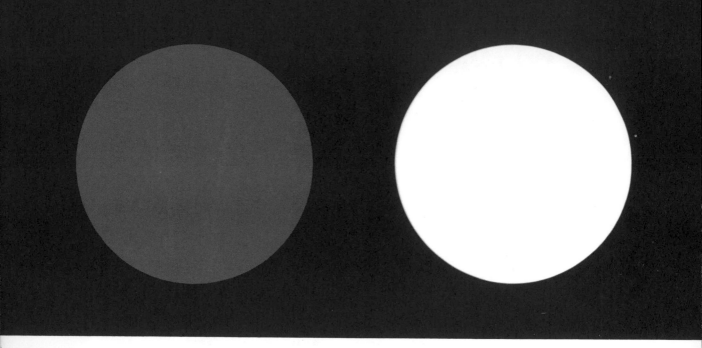

Plate 41

Plate 40

Plate 38

EDGE Plate 40 Both circles are blurred. However, the bottom circle may appear closer due to its position.
EDGE Plate 41
Which circle appears more distant ?

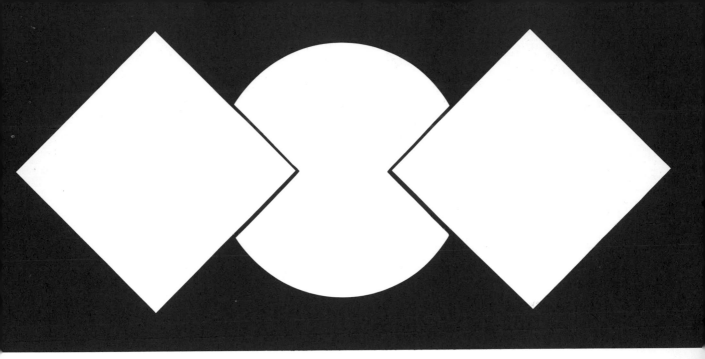

Plate 42

EDGE Plate 41 The blurred white circle may appear closer to us. The grey circle has a hard edge. Ordinarily a well defined edge can result in an illusion of nearness, but the grey value of this circle causes it to merge into the background.

The opposite interpretation is possible, in which the grey circle appears closer to us. The hard edge quality of this circle may result in its appearing closer to us, despite a closeness in value to the background.

OVERLAP Plate 42

The next few examples will illustrate how **overlap** can be used to create spatial illusion.

In this illustration we see the two square shapes overlapping the circle. The overlapped circle is made to appear most distant from us.

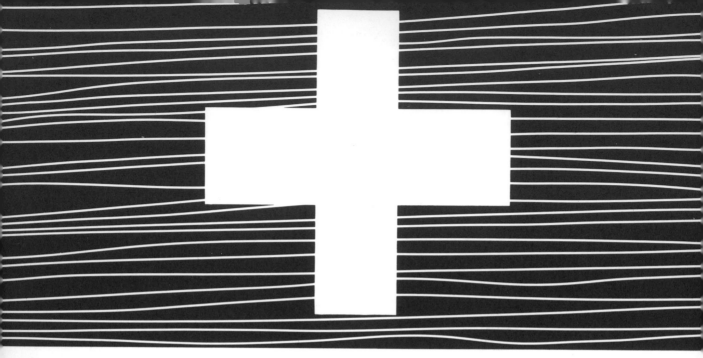

Plate 43

OVERLAP Plate 43
Visualize the white cross as a solid shape. We can interpret
the cross as overlapping a background of wavy lines and
therefore appearing closest to us.

Plate 44

OVERLAP Plate 44
The same elements used in the previous plate are shown
above. Notice how the spatial position of the cross has
shifted. Why does this shape now appear behind the wavy
lines?

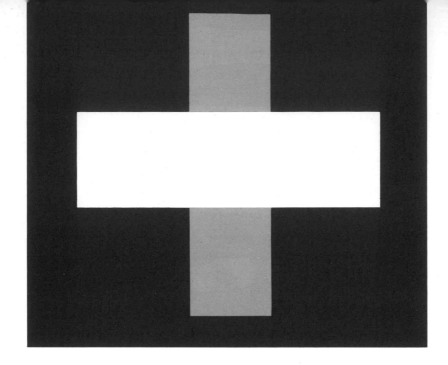

Plate 45

OVERLAP Plate 44 The cross appears behind the wavy lines because it has changed to grey while they remain white: the illusion is therefore due to a change in **value** relationship.

OVERLAP Plate 45

Do we see the horizontal or the vertical shape as closer to us? Give three reasons for your choice.

Plate 44

cording to him, each elementary portion of its surface is supplied with three nerve fibrils, adopted for the reception of three sensations. One set these nerves is strongly acted on by long waves of light, and produces the nsation we call red; another set responds most powerfully to waves of di length produci the sensation which e call green; and finally, hird set s ng stimul d sho wave an ene the kn vic he of the sp rum, ts p ully the t s of these erves; t, a ordi to Y ng the so e o er two s t w s en y. Th an is e o he en and violet rays of the spectrum: they each act on all three sets of rves, but most powerfully on those especially designed for their reception. this will be better understood by the aid of the accompanying diagram, ich is taken from Helmholtz's great work on "Physiological Optics".

SPECTRA

Plate 46

OVERLAP Plate 45 The horizontal bar appears closer
to us for the following reasons:
ı Overlap.
2 Value contrast.
3 Size difference.
OVERLAP Plate 46
This is a typographical example of overlap. Why do the
larger letters appear nearest ?

Plate 47

Plate 46

OVERLAP Plate 46 The large letters are covering up
many of the smaller sized words and thus appear closest to
us. The scale of the larger letters reinforces the illusion of
nearness.

OVERLAP Plate 47
Think of the grey area in this example as a background. Try
to visualize both the black and white squares as solid
shapes. The small shape appears closer to us. Which two
spatial qualities contribute to this illusion?

OVERLAP Plate 47 The small square appears closer to
us because it:

1 overlaps both the black square and the grey back-
 ground,

2 contrasts in value both with the black square and the
 grey background.

OVERLAP Plate 48
The apparent depth in this example appears to be very
shallow. Why?

Plate 48

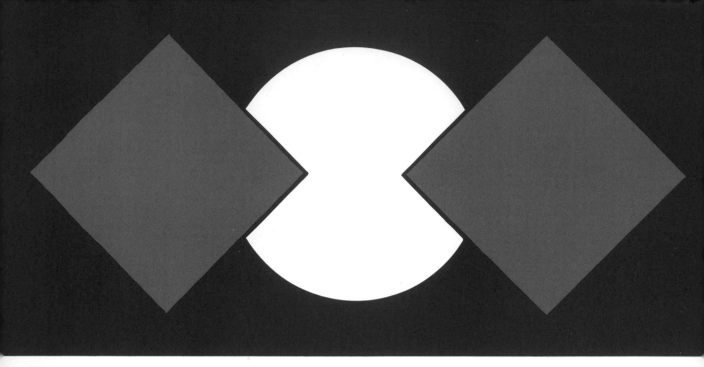

Plate 49

Plate 48

Plate 42

OVERLAP Plate 48 The shallow depth illusion is obtained here by the use of similar sized shapes, all having the same tonal value.

OVERLAP Plate 49

This illustration resembles a previous example that utilized the overlap (see Review Plate 42 below). Notice the difference between these two plates. Decide how this difference affects the spatial qualities in Plate 49 above.

We see that the central white shape appears closer to us due to a tonal contrast with its surroundings.

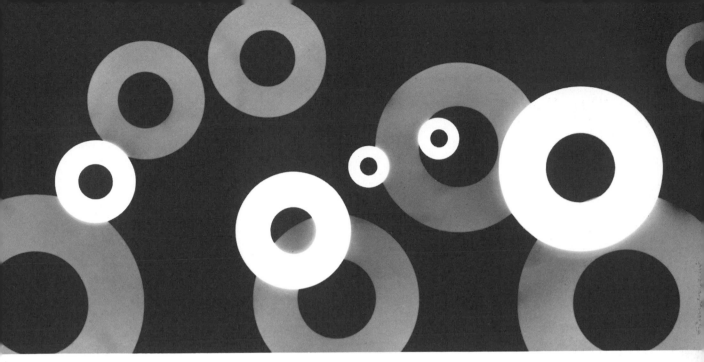

Plate 50

OVERLAP Plate 50
Discover at least three techniques used in this illustration to
obtain the illusion of depth.

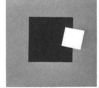

Plate 47

Plate 51

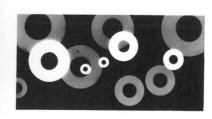

Plate 50

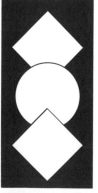

Plate 48

OVERLAP Plate 50 The three ways of suggesting depth
in this example are:
1 Overlap.
2 Blurred and sharp contours.
3 Value contrasts.
Compare the shallow depth suggested in Plate 48 with the
increased illusion of space in the above illustration.

OVERLAP Plate 51
Describe three techniques employed in this example to
show the quality of depth.

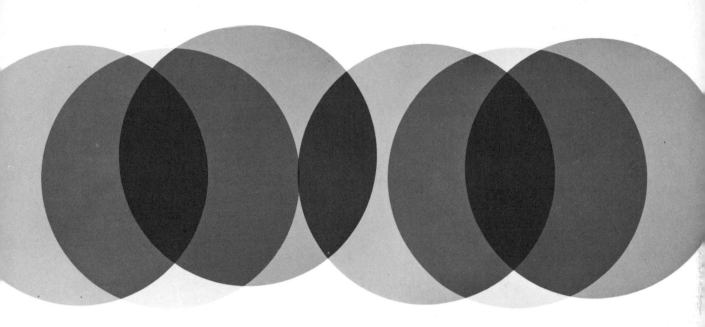

Plate 52

OVERLAP Plate 51 The three spatial qualities used in
this typographical example are:
1 Overlap.
2 Size.
3 Position.

TRANSPARENCY Plate 52

Another way of suggesting depth is by the use of trans-
parent forms and areas.

In studying the above illustration we may be undecided as
to which circle appears closest to us or most distant.
Although the shapes overlap one another, their transparent
qualities suggest spatial illusions that are shifting and
changeable rather than fixed. At one moment a circle
appears in front, then behind its neighbour.

Sculptors and painters often use this fugitive, changeable
quality of transparent form in their work.

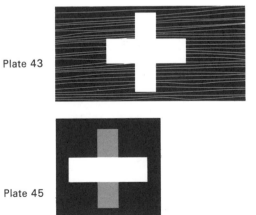

Plate 43

Plate 45

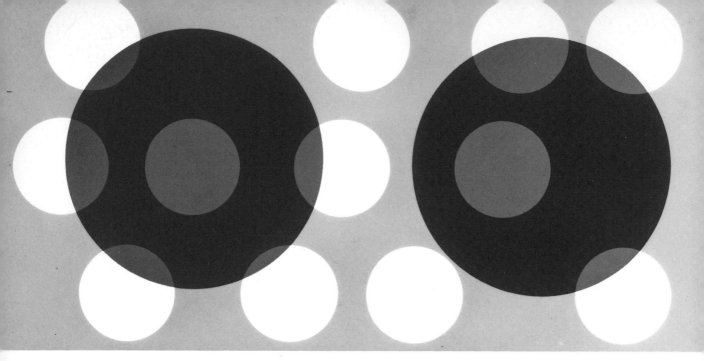

Plate 53

What is the apparent spatial position of the smaller circles in the illustration above?

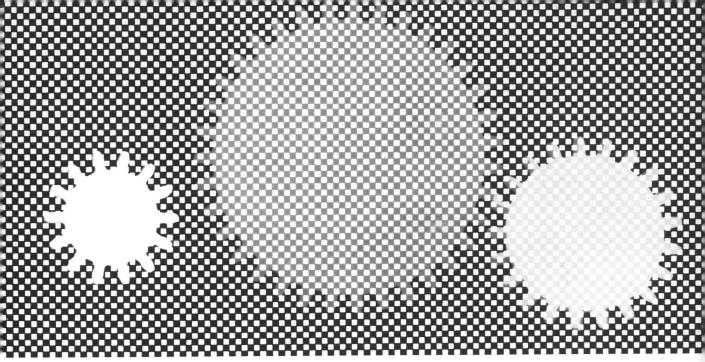

Plate 54

TRANSPARENCY Plate 53 The smaller circles appear to
be most distant from us. There are, however, two small circles
which are not overlapped by the larger ones: these two may
therefore appear a little closer to us than their companion
shapes.
TRANSPARENCY Plate 54
Which gear shape appears most distant from us? Why?

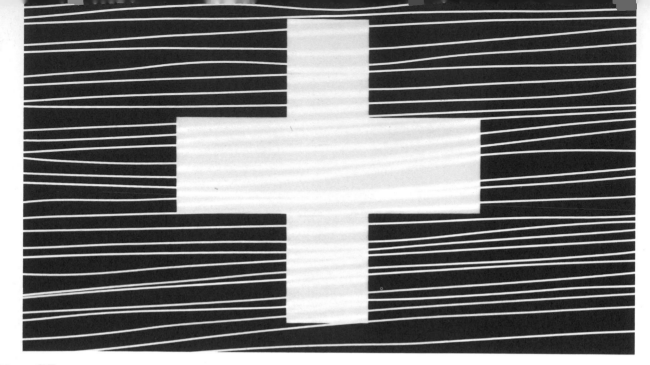

Plate 55

TRANSPARENCY Plate 54 The largest shape appears most distant, despite its size. The middle-sized gear can be interpreted as translucent in quality and closer to us. The smallest gear is more opaque and appears to be the closest to us, while the largest may even look as though it is positioned behind the background pattern.

TRANSPARENCY Plate 55

In this example, the white lines are clear and sharp edged against the black background. What happens when they appear in the light grey cross? The lines become blurred and displaced in their continuity. These qualities suggest that the cross is translucent and distorts the lines underneath.

By the usage of transparency and translucency, an architect can create variations in the appearance of his basic building materials. Architectural surfaces and forms viewed through glass or plastic can be made to shift in colour, value, shape and position.

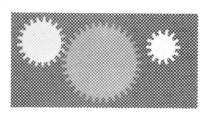

Plate 54

Plate 56

TRANSPARENCY
A typographical example utilizing transparency.

Plate 56

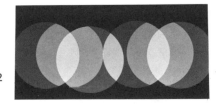

Plate 52

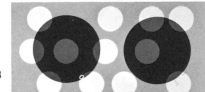

Plate 53

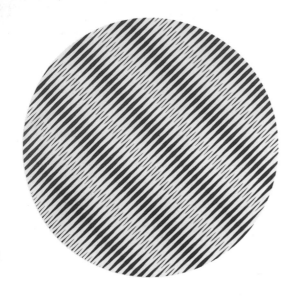 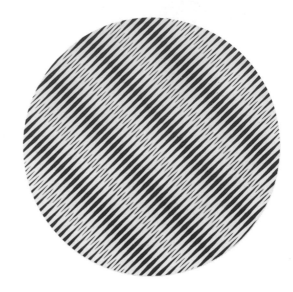

Plate 57

PATTERN Plate 57
The following illustrations demonstrate the spatial qualities
of contrasting patterns or textures. The two circles in this
plate are equal in size and pattern quality. Their similarities
make them appear an equal distance from us.

e upon a time a M se, a Bird, and a
into company toge er, and for a long tim
t house, living tog ther in great peace an
nfort, and increase their wealth famousl
vas the duty of the ird to fetch wood, of t
use to draw water a d make the fire, and
usage to cook. The who are prosperous
r hankering after mething new, and th
e day the Bird, mee ing another bird on h
y home, told him her condition, and b

Plate 58

PATTERN Plate 58
The two areas of type are similar in size, shape and tone.
Their similar pattern or texture causes them to appear equi-
distant from us.

Plate 59

Some patterns may be active and 'loud' while others are 'quiet' and have less of a vibrating quality. Textures can vary from rough to smooth. Patterns and textures may attract our attention, due their degrees of contrast. Others can go practically unnoticed.

In this illustration, which pattern appears closer to us based on its active and vibrating qualities?

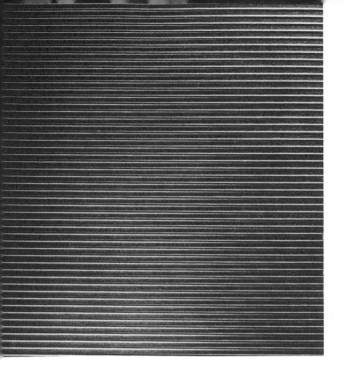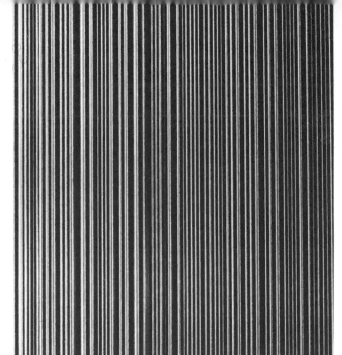

Plate 60

PATTERN Plate 59 The righthand pattern seems to
vibrate the most. For this reason it may appear closer to us.
PATTERN Plate 60
These patterns are available as architectural aluminium
sheets. Notice that one is more active than the other, and
may appear closer to us.

abcdefghijklmnopqr
stuvwxyz ABCDEF
GHIJKLMN 123456

abcdefghijklmnopqrstuv
wxyz ABCDEFGHIJKLM
NOPQRSTUVW 1234567

abcdefghijklmnopqrstuvw
xyz ABCDEFGHIJK
LMNOPQRST 1234567

abcdefghijklmnopqr
stuvwxyz12345678
ABCDEFGHIJKLM

Plate 61

PATTERN Plate 61
Type styles also possess widely different textural qualities:
some are very plain and mechanical looking, others are more
ornate and flowing.
Shown here are four very different styles.
Notice their textural differences.

Graphic Perception of Spac... | Graphic Perception of Spac... | **Graphic Percepti...** | **Graphic Percepti...** | Graphic Perception ... | Graphic Perception of... | **Graphic Perception** | Graphic Perception of S... | *Graphic Perception* | **Graphic Perception** | **Graphic Percepti...** | Graphic Perception of S...

1. 2. 3. 4. 5. 6. 7. 8. 9. 10. 11. 12.

Plate 62

PATTERN Plate 62

The type specimens in this example are different in style or 'texture' but not substantially different in size. Do some lines appear closer to you than others?

Obviously, since some are set in bold face and others in light face type, they differ in 'weight'. Also, some letters are larger than those in other lines. These differences in weight and size will account partially for their spatial differences. But differences in the textural quality of type styles can be an added factor when comparing them spatially.

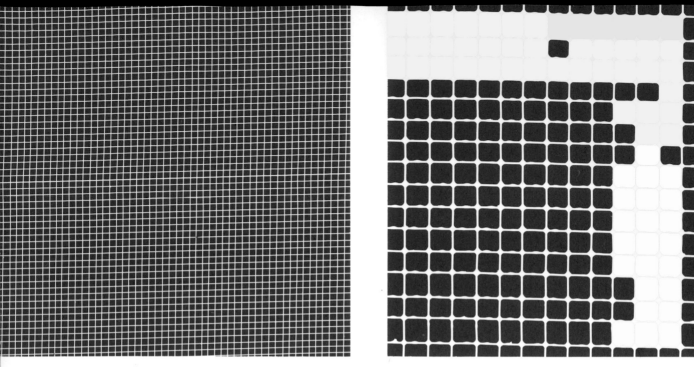

Plate 63

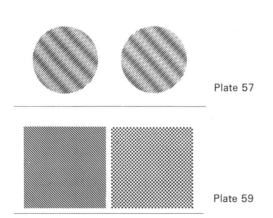

Plate 57

Plate 59

PATTERN Plate 63

A texture or pattern often attracts our attention if it has a bolder and more intensely vibrating quality than any of the neighbouring areas.

In the above example the lefthand screen may appear greyer than its larger counterpart. Although both pictures are comprised of pure black and white values, the righthand screen attracts us by its bolder pattern. We conclude that an apparent enlargement of a texture or pattern causes it to appear comparatively closer:

1 Through an increase in scale.
2 Through an intensified boldness and visual complexity of the enlarged area.

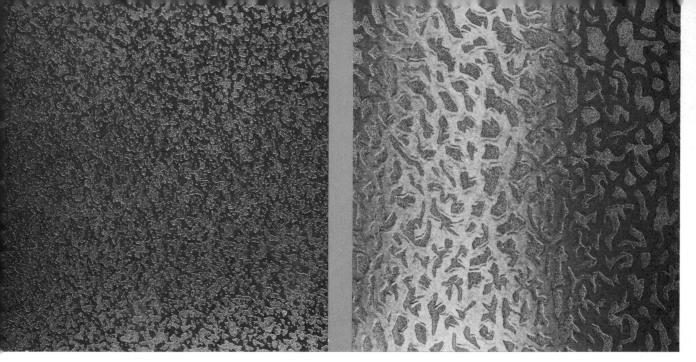

Plate 64

PATTERN Plate 64

Here are two patterns of architectural aluminium panels.
Apart from their decorative appeal they illustrate spatial
qualities due to a difference in the scale of their patterns.

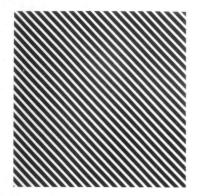 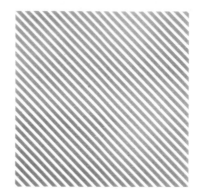 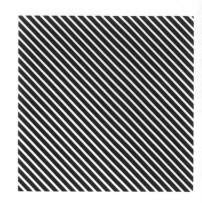

Plate 65

PATTERN Plate 65
Study this example for its spatial qualities. A similar pattern
is shown here in three squares of equal size. They each differ
in value. Which pattern appears closest to us?
It is the righthand square that appears closest due to the
vibration of black lines against white. We can conclude that
an increase in value contrast can result in a spatial shift
towards us.
If we think of the above patterns with their variations in value
as fabric samples, etc., we can see how the interior designer
uses decorative materials as spatial elements.
PATTERN Plate 66
Shown on the opposite page is a decorative use of pattern or
texture. At the same time there are spatial effects due to
overlapping changes of pattern.

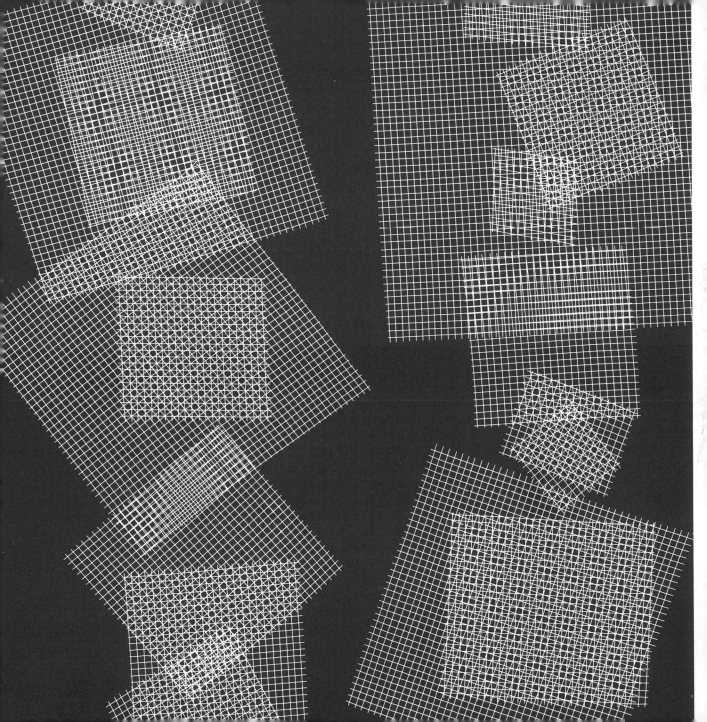

abcdef3

abcdefghijklmnopqrstuvwxyz
ABCDEFGHIJKLMNOPQRS

abcdefghijklmnopqrst
ABCDEFGHIJKLMN

abcdefghijklmnop
ABCDEFGHIJKL

abcdefghijklmr
ABCDEFGHIJI

abcdefghijk
ABCDEFGH

abcdef3

ABCDM

abcdf3

ABDW

Plate 67

Plate 62

Plate 63

PATTERN　　　　　　　　　　　　　　　Plate 67

As previously shown, certain type styles differ in their textural qualities. The differences can cause contrasting styles of type to take on comparative spatial positions on the printed page.

In Plate 63 we noted that an enlarged version of a pattern can attract our attention more readily than its small scale counterpart.

Notice in Plate 67 that the body of type on the right appears bolder. It may even seem to vibrate more intensely than the lines at the left. Increases in size and in the degree of textural intensity are the two qualities that cause the larger type to stand out more.

abcdefghijklmnopq
ABCDEFGHIJKLMNA

abcdefghijklmnopqrstu
ABCDEFGHIJKLMNJK

Plate 68

PATTERN
Plate 68
Which area of type appears closest to us?

Plate 58

Once upon a time a Mouse, a Bird, and a Sausage
fell into company together, and for a long time
kept house, living together in great peace and
comfort, and increased their wealth famously
It was the duty of the Bird to fetch wood, of the
Mouse to draw water and make the fire, and of
Sausage to cook. They who are prosperous are
ever hankering after something new, and thus
one day the Bird, meeting another bird on her
way home, told him of her condition, and boa

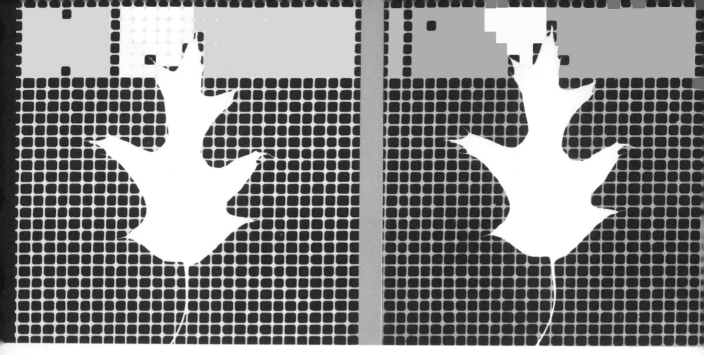

Plate 69

PATTERN Plate 68 The top area appears closest. This is due to a more active type style 'texture' and a high value contrast between the top line and its white background. As a comparative type style, the bottom line is 'quieter', both in texture and value contrast.

PATTERN Plate 69
Visualize the white leaves as solid, opaque forms. The background to each leaf is shown as a screen pattern. Both backgrounds are of a similar size but of different value.
Which screen pattern appears more distant from the fore-ground leaf? Make a choice below.

A Lefthand screen.
B Righthand screen.

abcdefghijklmnopq
ABCDEFGHIJKLMNA

abcdefghijklmnopqrstu
ABCDEFGHIJKLMNJK Plate 68

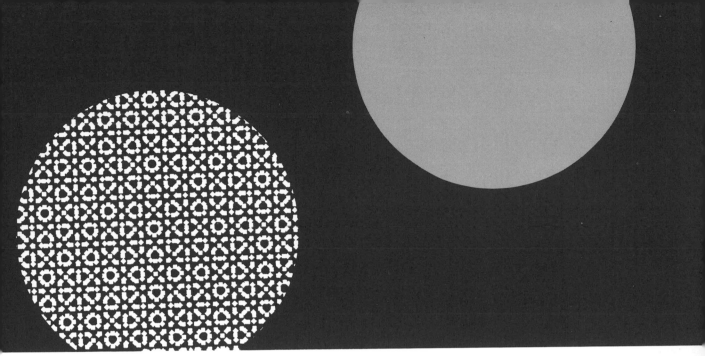

Plate 70

PATTERN Plate 69 Choice B is **correct**.
As a pattern, the righthand screen is darker and merges with
the black background.
It may also be that the righthand leaf appears closer to us
than the other. Why is this?

PATTERN Plate 70
Both circles are similar in diameter.
Which one appears closer to us?
Give two reasons to support your conclusion.

Plate 65

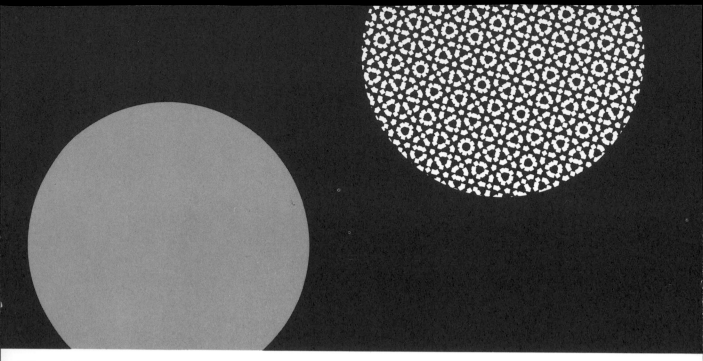

Plate 71

PATTERN Plate 70 The lefthand circle appears closer.
1 It has a very active black and white pattern compared to
 the overall grey of the other.
2 The lefthand circle is located at the bottom.

PATTERN Plate 71
In this illustration you may visualize either circle as closer.
The patterned circle is more likely to attract your attention
first.

Plate 70

Plate 72

PATTERN Plate 72

Which screen pattern appears more distant?
Give three reasons for your choice.
The lefthand screen appears more distant because:
1 It is the smaller of the two patterns.
2 The larger pattern appears to overlap the smaller.
3 The lefthand screen is the smaller of the two.

Plate 69

Plate 67

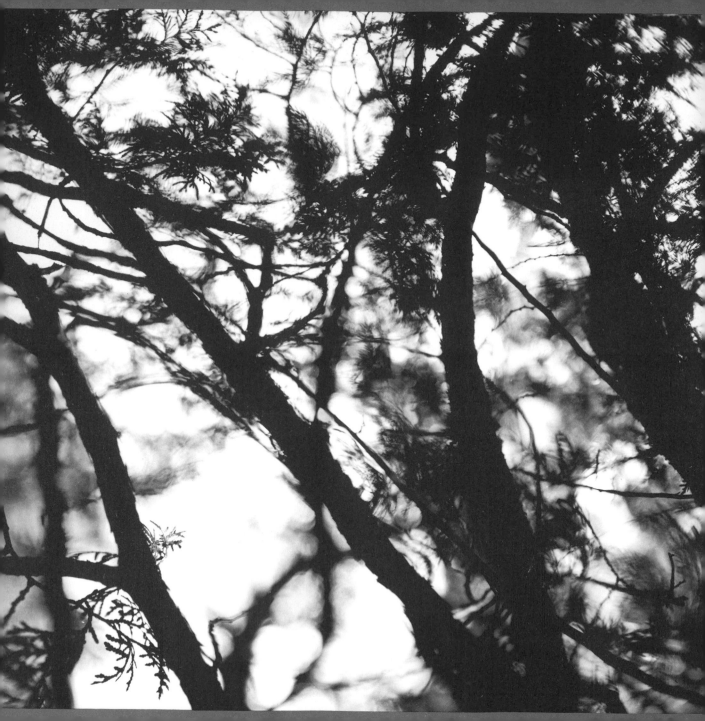

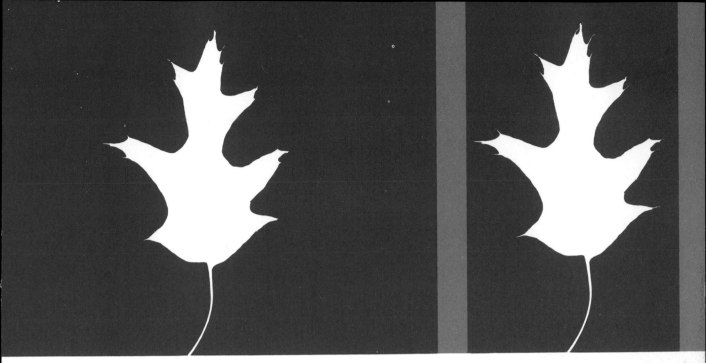

Plate 74

PATTERN Plate 73

The spatial qualities in the photograph on the opposite page
are created through the interweaving and overlapping tree
patterns. These patterns are:

1 Large and small.
2 Blurred and sharp edged.
3 Black and light grey in value.

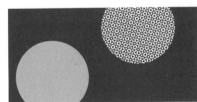

Plate 71

FORMAT Plate 74

There is yet another visual illusion that can contribute to a
graphic perception of space.

This is described here as the comparative size of format.

We define 'format' as size or scale of a compositional area.
The leaves in this example are identical in size, shape, value
and vertical position. How do they differ?

Plate 72

They differ in format size, with the righthand leaf contained
within a smaller format. Study both shapes in their respec-
tive formats. Decide which leaf appears closer to us.

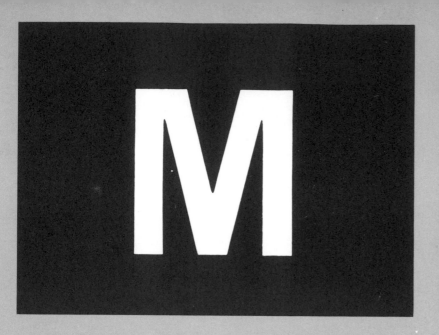
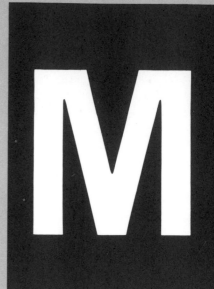

Plate 75

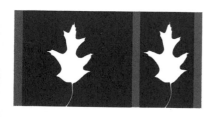

Plate 74

FORMAT Plate 74 If you chose the righthand leaf in its small and confining format—**correct**.
The lefthand leaf within its relatively spacious format appears slightly smaller and thus more distant.

FORMAT Plate 75
Apparent shift in spatial position due to a change in the size of a format can be judged only after some degree of practice. The same holds for the other spatial effects described in this volume.
Which 'M' appears closer in the above illustration? Make a choice below.

A The righthand 'M' appears closer. This is due to the smaller size of its format.

B Both letters appear to be the same distance from us.

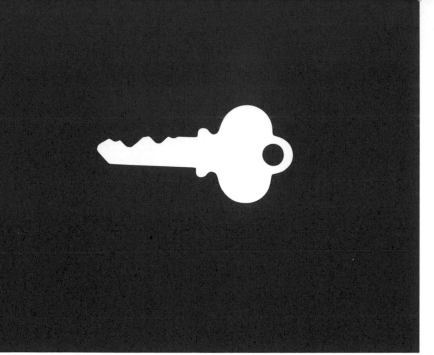
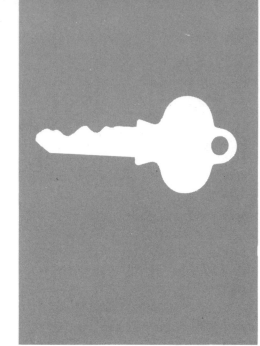

Plate 76

FORMAT Plate 75 Choice A is **correct.**
Compare carefully the apparent size of each letter. Which
'M' appears larger? Notice that the righthand M is
confined within the smaller format: this makes it appear
slightly larger than the companion letter. If the righthand
M looks larger, we can interpret it as being closer to us.

FORMAT Plate 76
Study the example above for comparative spatial qualities.
Both shapes in white are the same size. Which key appears
more distant?

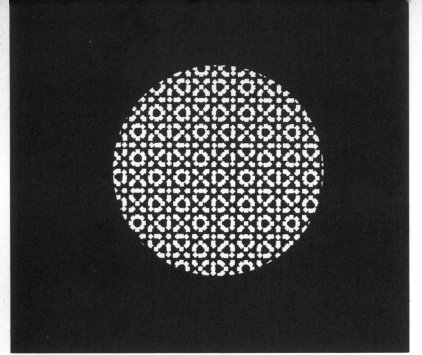

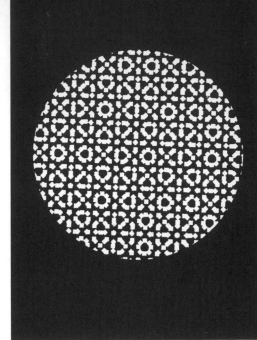

Plate 77

FORMAT Plate 76 Although it is in the smaller format the righthand key appears more distant. Notice the lack of value contrast between this key and the light grey background.

On the other hand there is a strong degree of contrast between the lefthand key and its background.

FORMAT Plate 77

Both patterned circles are the same size. Only their formats differ. Which pattern appears nearer to us?

Plate 76

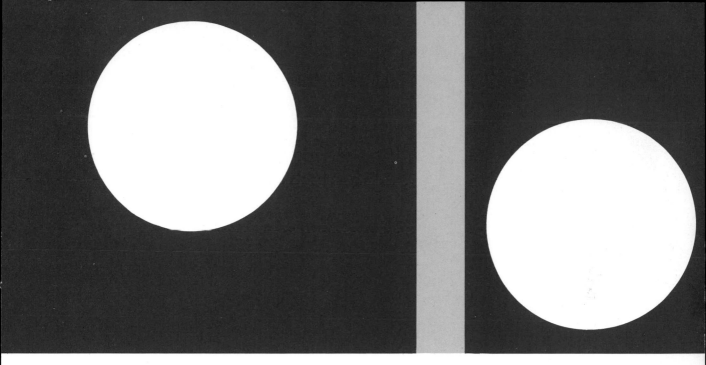

Plate 78

FORMAT Plate 77 The righthand pattern appears closer,
due to its smaller format.
FORMAT Plate 78
Both circles are the same size.
Which one appears closer to us?

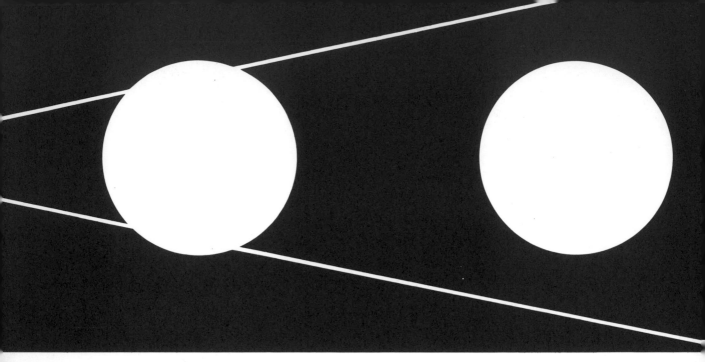

Plate 79

Plate 78

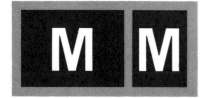

Plate 75

FORMAT Plate 78 The righthand circle appears closer. It is within the smaller format and is positioned at the bottom.
FORMAT Plate 79
Which circle appears closer? Both are the same size.

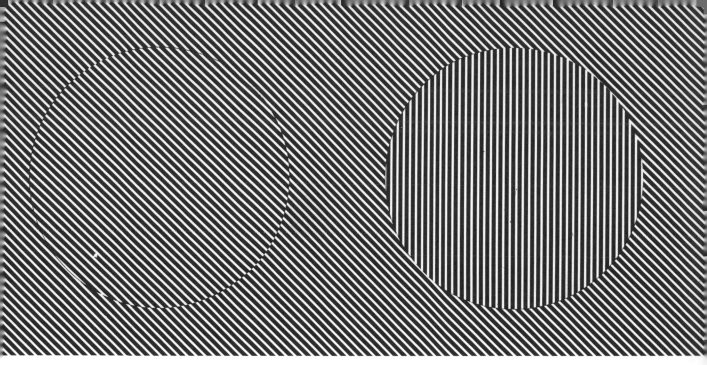

Plate 80

FORMAT Plate 79 Two converging lines act as bound-
aries of a background or format for the circles in this
illustration. It is this format, bounded by two lines, that
gradually decreases in height and causes the narrowly
confined circle on the left to appear closest to us. It also
overlaps the background format.

Examples in this volume have utilized the spatial effects of
comparative Size, Value, Position, Edge, Pattern, Overlap,
Transparency and Format. You have been asked to interpret
these differences as visual cues towards the creation of
spatial qualities.

ISOLATION Plate 80

The circles in this example may be given a spatial interpret-
ation. The righthand circle can be interpreted as closer to us.
We can also conclude that this circle attracts our attention
first. This is due to an abrupt interruption of the surrounding
background pattern.

The following plates illustrate ways of isolating one form
from its neighbouring shapes.

85

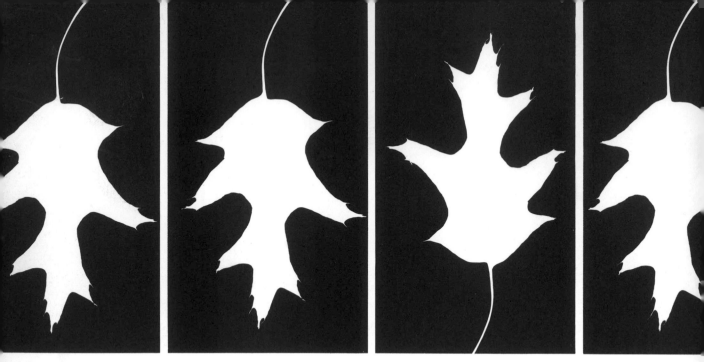

Plate 81

ISOLATION Plate 81
Directing the focus of attention is important in all visual
media and a good example is the front page of a newspaper.
Although the reader is free to glance at random from item to
item, it is the banner headline that attracts his attention first.
In a work of art our attention is often attracted to areas that
contrast clearly with their surroundings. Notice that your
attention is quickly drawn to the only 'right-way-up' leaf in
the above illustration.
There is no attempt here to express spatial qualities, only to
illustrate methods of focussing attention on a specific area.

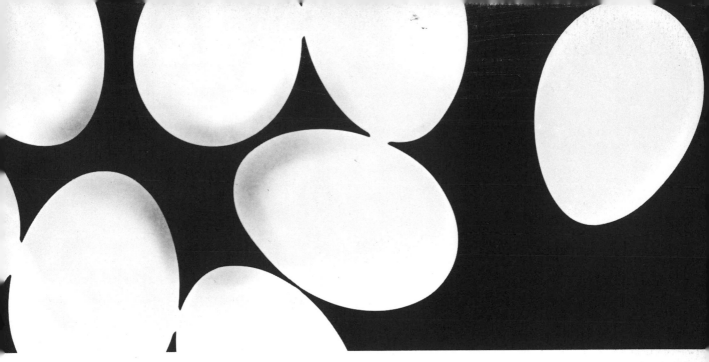

ISOLATION Plate 82
There is one shape separated from the group. For this reason
we tend to focus our attention on it first.

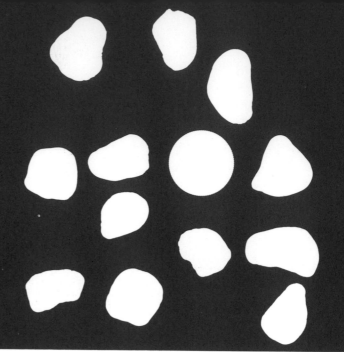

Plate 83

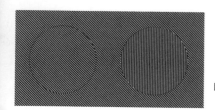

Plate 80

ISOLATION Plate 83
Study the illustration above for shapes 'seen first'.

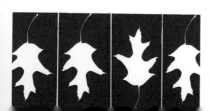

Plate 81 88

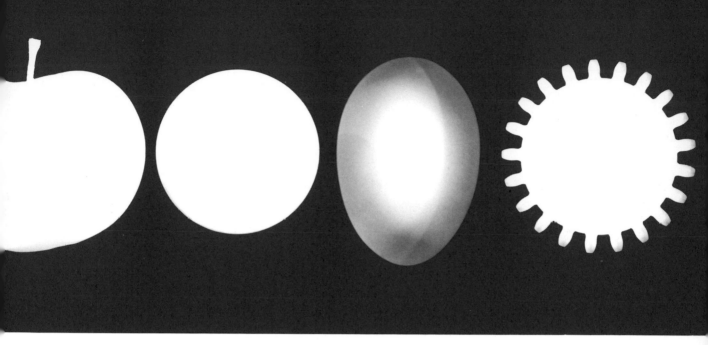

Plate 84

ISOLATION Plate 84
Although each shape is different, which one is outstanding-
ly different from the rest ?

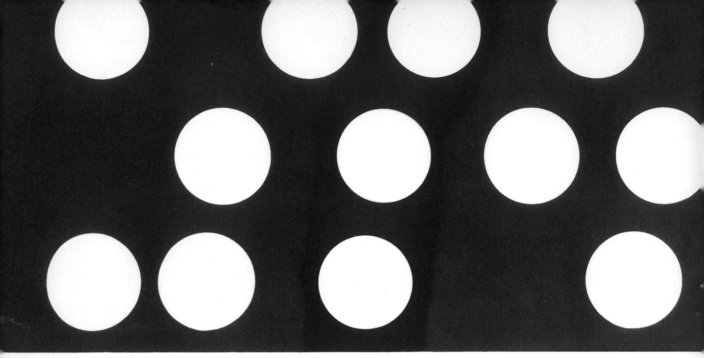

Plate 85

ISOLATION Plate 84 The gear shape at the right differs most. The gear tooth pattern causes this shape to vibrate in a visual way, thus attracting our attention. The egg also differs from the others in value.

ISOLATION Plate 85
Notice how the isolation of certain shapes is obtained in this example.

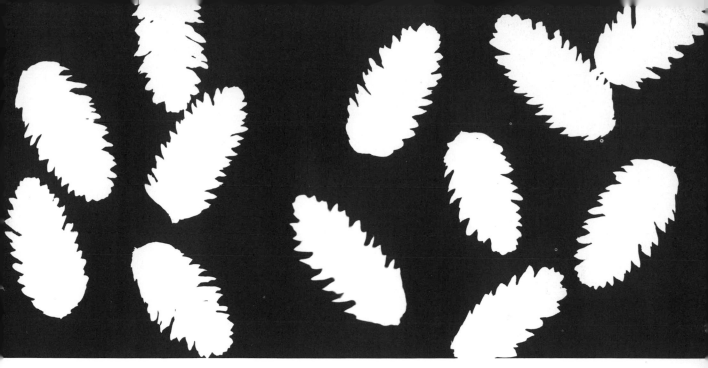

Plate 86

ISOLATION Plate 86
Notice how one shape stands out from the others.

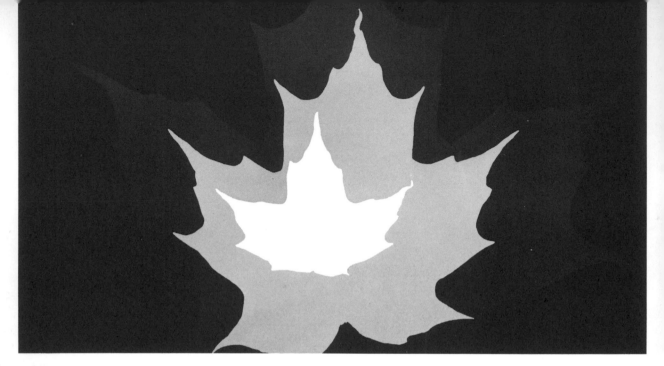

Plate 87

Plate 82

Plate 83

ISOLATION Plate 87
Here is a 'nest' of similar shapes.
Why does the small leaf stand out most?

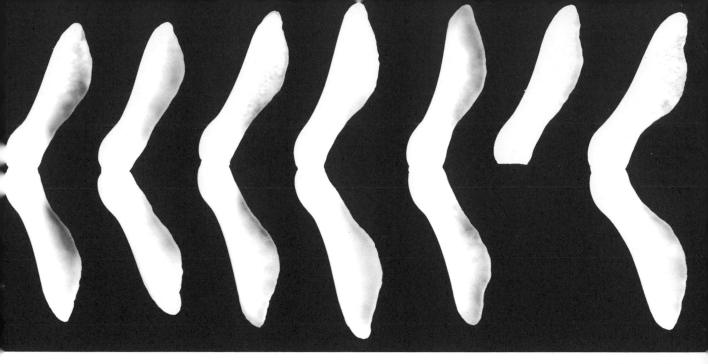

Plate 88

ISOLATION Plate 87 The smallest leaf overlaps the other two and has the most contrast in value with the dark background.
ISOLATION Plate 88
A fragmented shape will stand out from a group of completely formed counterparts.

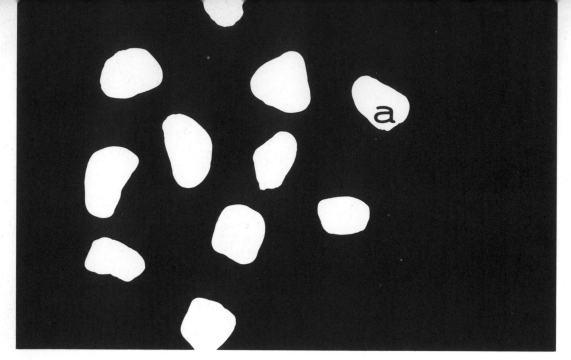

Plate 89

ISOLATION Plate 89
The letter placed within one pebble shape makes it stand out
from the other forms.

Plate 90

ISOLATION Plate 90
In design planning the readability or clarity of form is important.
This example makes use of just one form against a plain background. The uniform and contrasting background helps to accentuate or isolate the white cross.
Our capacity for spatial judgement makes us ready to structure what we see. For example, this is true when trying to decipher a barely readable television image.
In the medium of sound we no longer have to endure distortion of sound that is inherent in A.M. reception. Stereophonic F.M. can give us distortion free, dimensional sound. With stereophonic sound a reality, stereo picture transmission on a mass basis may soon be possible. We will then find ourselves immersed in the complexities of a spatial communications medium. As viewers or creators of this medium we should be ready to deal with such an eventuality.

Plate 88

GLOSSARY

| | |
|---|---|
| Boldface | Typefaces that are heavy weight and bold in effect. |
| Column | Several lines of type. |
| Edge | Contours having either blurred or sharply defined qualities. |
| Format | The comparative size of a compositional area. |
| Isolation | The uniqueness of a form among others. |
| Lightface | Typefaces that are light weight in appearance. |
| Media | Vehicles for mass communication such as television or magazines. |
| Medium face | Typefaces that are normal in thickness or weight. |
| Overlap | The covering of one area by another. |
| Pattern | Surface decoration utilizing obvious repetition. |
| Point | The standard unit for measuring type sizes. |
| Position | The relative placement of visual elements in a composition. |
| Scale | Comparative differences in size. |
| Texture | Surface quality such as smooth, rough or pebbled. |
| Tone | Gradations of value between white and black. |
| Transparency | A quality that allows us to see through materials. |
| Typeface | Letterforms used in printing of differing styles and sizes. |
| Typography | The art of composing and printing type. |
| Value | The amount of light or dark tone within a given area. |
| Weight | The visual heaviness or lightness of a typeface. |